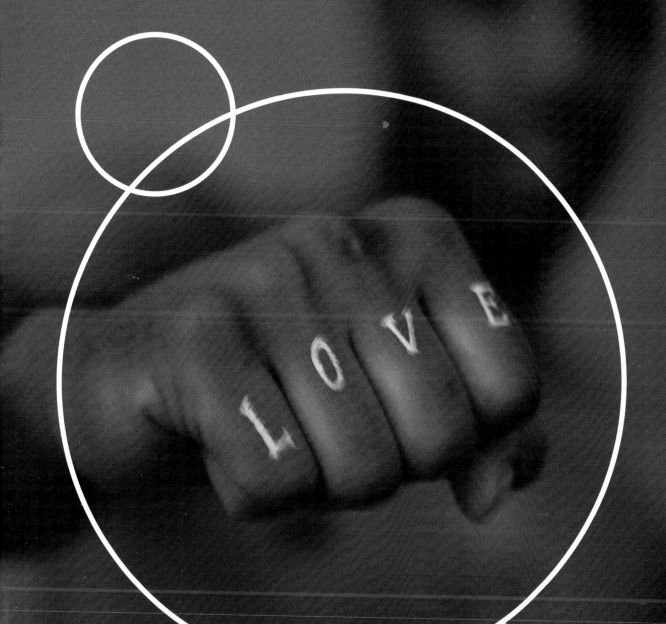

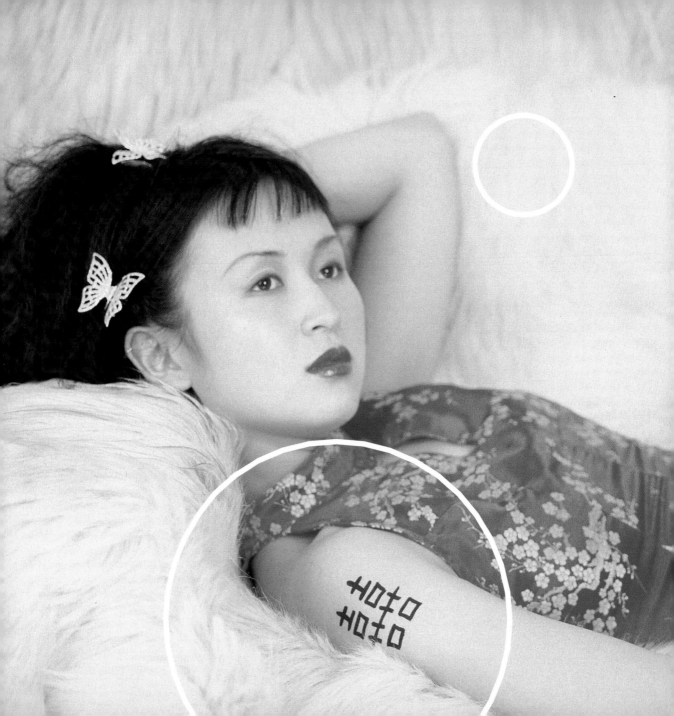

body art
chic

barry bish

with photography by laura hodgson

trafalgar square publishing

for Serena

First published in the United States of America in 1999 by Trafalgar Square Publishing
North Pomfret, Vermont 05053

Printed and bound in Singapore by Tien Wah Press

ISBN 1-57076-156-6

Text © 1999 Barry Bish
Photography © 1999 Laura Hodgson
Design Button Design
Backdrops painted by Barry Bish
Editor Kate Oldfield
Make up Yu Mei Chan
Models from Angels model agency
Clothes by Suture and De Nico of London

Published in Great Britain by Kyle Cathie Limited

Barry Bish is hereby identified as the author of this work in accordance with Section 77 of the Copyright, Designs and Patents Act 1988

Library of Congress Catalog Card Number: 99-63644

Visit our web site at www.trafalgarsquarebooks.com

Here at last is a do-it-yourself book of body adornment. Have you ever wondered how to get your hair into those funky little knots? Have you longed for a temporary tattoo and didn't know you could make your own?! If so *Barefaced Chic* is for you and for thousands like you all over the world who dare to bare their bods and display their favourite body art.

Although mankind has used colours, markings and jewellery to display rank, status and tribe for thousands of years, until fairly recently body art has had 'ethnic' overtones (such as the henna designs of India, North Africa and the Middle East) or, in the form of tattoos and piercing, it has had an agressive 'bad boy' image that was bound to offend your parents. Now all that has changed. For a start nothing has to be permanent! Designs are attractive and exciting and you can find a design to suit you, whoever you are. Just turn the pages…

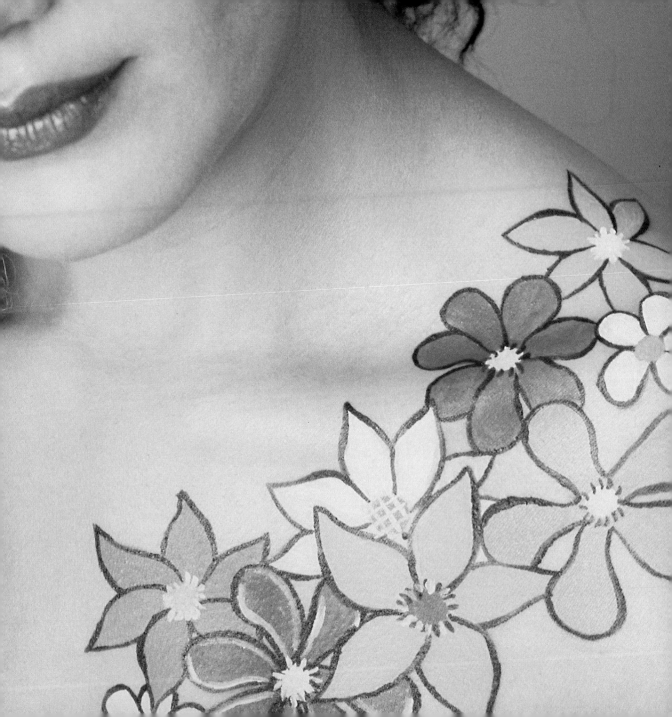

toos tattoos tattoos tattoos tattoos tattoos tattoos tattoo

The word 'tattoo' comes from the Polynesian word *tau tau*. It entered the English language after Captain Cook visited Polynesia in 1764. Originally tattoos were symbols which were meant to give the wearer special powers (firefighters wore images of dragons to help them harness fire), but today temporary tattoos have moved into the mainstream to become sought-after fashion accessories.

Let your designs be influenced by different areas of the globe. Try tribal-style tattoos – simple silhouettes, and bold designs which interweave patterns such as the flowing curves and spirals of the Maori Moka (see page 70). Play with the geometrical patterns of Polynesian tattoos. Experiment with Celtic scrolls and interlocking patterns which work wonderfully as bracelets, arm and ankle bands (page 20). Of course if you are a bit of a dab hand with the paint brush you can invent more realistic animal shapes influenced by the rich symbolism of Japanese tattoos – dragons, lotus flowers and carp . We realise, however, that this is a tall order, so we have given you a simple butterfly on page 34.

Create your own temporary tattoos using tattoo inks and a fine paint brush. Use your designs to highlight and accentuate: a small heart on your upper arm, a blue dolphin on your ankle... Try a small beauty spot on your cheek for film-star glamour!

Temporary tattoo transfers also do a fantastic job and create bold stylish statements easily and immediately. Be warned, however, some of them can look *really* fake, so shop around until you find ones that look authentic.

A word of warning: if you decide to get a permanent tattoo then it is *extremely* important that the tattoo shop you choose must be open to inspection to ensure they meet stringent hygiene and sterilisation procedures. Contact the Association of Professional Tattoo Artists (see page 94) which have over 800 members worldwide for a professional recommendation.

Never ever attempt to tattoo yourself, or go to an unlicensed tattoo artist, and never get tattooed on the spur of the moment! A permanent tattoo that you think is cool today may not be a few years down the road...

Basic Kit

Tattoo inks (see pages 94 for stockists)
Fine art brush
Transfers and self-adhesive tattoos

henna henna **henna** henna henna henna henna henna

Madonna really brought this look to the fore in her video *Frozen*. Since then Naomi Campbell has been known to fly to New York to get her hands painted, the artist formerly known as Prince has revealed his painted palms and exotic designs have appeared on the bodies of the trendy from Tokyo to Berlin. Demi Moore, the queen of body art, had her hands done for her wedding.

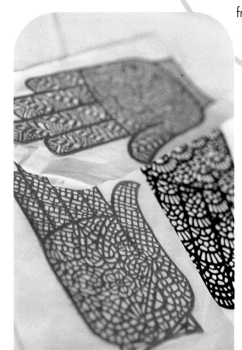

Henna (or *mehndi*, from the Hindu word for henna) is a semi-permanent plant-based dye. Designs made with real henna will last on your skin for between 1 and 4 weeks. It is traditionally used on the hands and feet in parts of India, Pakhistan, north Africa and Turkey as part of womens' celebrations. The use of red henna is believed to attract good luck and good health. It is thought that the practice may have been started in Persia to decorate brides who were not rich enough to afford expensive jewellery.

Applying real henna, however, is time consuming and very fiddly. It can also take up to two days for the

design to darken and look its best – so you have to plan ahead. Henna kits are readily available at Indian fashion stores and most good make-up shops – make sure they come with complete instructions. For special occasions why not visit a professional henna artist (see page 94).

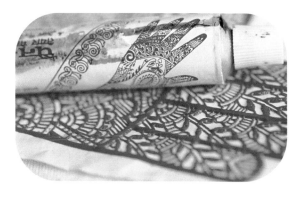

There are ways to avoid all this planning and fiddling! To achieve a similar look without the wait, there are a number of 'henna-look' pencils available and some great henna-inspired temporary tattoos and transfers. L'Oréal have even brought out a 'white' mehndi pen (see stockists on page 94). Use the 'henna look' to draw attention to the bits of your body that you are proud of; try an armband on shapely arms, a ring of flowers around a delicate ankle, a geometric squares around your belly button or Indian-inspired paisley pattens on your palms and feet. Henna-type designs look fantastic with a tan so if you are going on a beach holiday stock up!

Rubber stencils are available from Indian shops, and some cosmetic companies, through which you can paint directly on to the hands to make authentic patterns.

Basic Kit

'Henna-look' pens and pencils (like liquid eyeliner and kohl pencils)
'White' henna is also available (see page 94 for stockists)
Henna-look transfers
Rubber stencils

11

ñail art **ñail art** ñail art ñail art ñail art ñail art

Nail art was popularised in the United States – the home of the 'nail bar' (small shops which excell in quick and amazing manicures and pedicures).

Before you start, make sure that you have got everything that you need. A collection of basic nail glosses is essential: black, white, gold, silver, red, blue, green, yellow, pink and brown. You may also want to get some glitter varnishes. Add to your stock as you come across new colours. For large patches of colour use nail varnish, for delicate patches use water-based paints and a very fine paint brush.

First things first. Keep you nails in order with regular care. Trim and file away breaks and splits as soon as they appear to stop them from spreading. Other than that, file your nails regularly, about once a fortnight to a month (depending on how fast they grow). Use a broad and gentle emery board which will not damage your nails. And

remember, always remove your varnish with acetone-free remover to stop your nails drying out.

(A good tip to keep in mind when painting your nails or removing your nail art designs, always start at the outside (little finger) and work your way in – it's so much easier that way, it avoids accidental smudging!)

Once you have worked on your nail beauty you are ready for the nail art! The simplest nail art is done using bought transfers and stencils (see page 48 and 54), just apply your base coat, two coats of your colour and, when your varhish is dry, apply the transfers or stencil colour. Finish with a coat of glaze and… Bob's your uncle! If you want to paint perfect straight lines then use nail striping (available from good nail mailorder suppliers, see page 94). For extra sparkle add rhinestones, sequins or tiny body jewels (see page 94), they come in all colours and can be added to your nail with a dot of glaze and then sealed with another coat. For a totally original look you can even cut out tiny pictures from magazines and add them to your designs!

Basic Kit

Nail varnish

Nail transfers

Undercoat and top glaze

body jewels **body jewels** body jewels body jew

Create your own personal style drawing bejewelled inspiration from Indian beauty rituals and from stars such Helena Christiansen, Cerys of Catatonia and Denise Van Outen. You can buy bindis from Indian shops and many funky fashion outlets. They are available in countless designs, shapes and colours. Choose a colour to match your jewellery or clothes. Don't just stick to bindis though, use a combination of makeup and body jewels as we have on pages 62–65, or attach tiny jewels with false-eyelash glue to highlight you cheekbones and eyes.

Basic Kit
Bindis
Eye jewels
Sequins
Multicoloured plastic gems

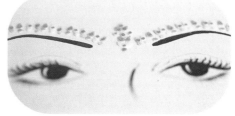

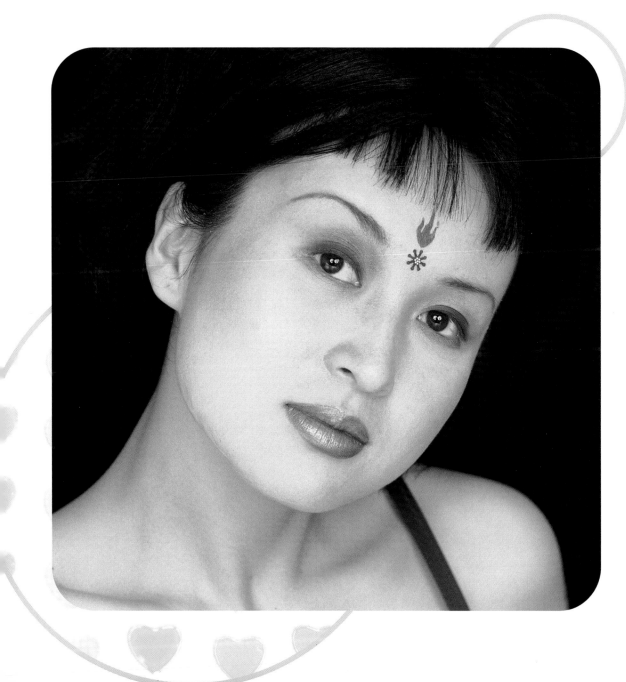

ody paint # body paint body paint body paint bod

Everyone who saw the photograph of Demi Moore in full body makeup on the cover of *Vanity Fair* magazine or the sight of Robbie Williams painted into a pair of blue jeans (brave boy!) will never forget it. This is body art at it's biggest, boldest and best. If you want to go down this route, say you want to look totally silver for a party (see page 64) or ever since watching the James Bond film who wish to look as if you have been touched by Goldfinger, then you will need grease paint or water-soluble paint. (Make sure that you use an astringent on the skin first to remove excess grease and moisturiser). Use long even strokes and be very careful to set the design with powder afterwards. And remember that you are wearing it otherwise you could end up as one big smudge! Spray on paint is easier to apply to large areas (and some are good

for using on the hair too). They come in a range of colours and glitters.

The secret of using body paint is to keep your designs simple and strong. A sillhouette of an animal shape (see flap stencils) or a simple heart will grab the attention just as much as a huge look-at-me design – and might actually be better for being subtle!

Look on pages 70-76 for inspiration.

Most body art cosmetics are water-based skin-friendly pigments. These wash off most easily – just use soap and water. Grease-based paints are best removed with lots of cold cream or baby oil and then soap and water.

Face and body paints are available at costume shops as well as specialist make-up shops (such as Screenface who have an international mailorder service – see stockists on pages 94).

Use the stencils that we have given you on the flaps of the book to get started. You can use these again and again so keep them in a safe place. You can also make your own stencil. Make sure you choose a simple shape and cut it out carefully with a sharp craft knife.

Basic Kit

Body paints in a range of basic colours (flourescent, luminous, ultraviolet for clubbing) – children's face paints are cheaper but poorer quality.
A selection of brushes

17

hair design hair design hair design hair desig

Whatever the length your hair you can add coloured hair mousse or add stripes of hair mascara, you can even use the stencils in the book with spray colour to add an inspirational flash to your style.

All kinds of hair look great with hair slides, and if you have a fringe why not pull it back using cute butterfly or bulldog clips?

If your hair is long you can knot it up in two little cones or funky little knots... Just go for it!

Basic Kit

Hair grips

Clips of all descriptions

Covered elastic bands

Hair brush and comb

Coloured hair mousse and mascaras

Water spritzing spray

Hair gel and hair spray... blah blah blah

piercing

piercing piercing piercing piercing piercing piercing

Evidence of belly button piercing goes back as far as the ancient Egyptians, whose princesses displayed jewels in their navels to show their important status. Today piercing is becoming more and more visible on the streets, popularised by pop stars such as the Spice Girls and Boyzone.

Never attermpt to pierce yourself. Choose a reputable piercer, who is scrupulous about hygeine and sterilisation and meets the strict conditions of an environmental health certificate. They may refuse to pierce you if you are under 18 years old. Contact the Association of Professional Piercers for advice (see page 94). Buy your body jewellery from there after a consultation ensuring that it is sterilised, prepacked and of surgical quality. After your pierce has been done you should be given written instructions on aftercare and cleaning.

Tattoos around the upper arm are becoming ever more popular. Celtic bands and organic designs are appearing everywhere from New York to Moscow. The designs opposite elaborate on those themes. On the front flap of the cover you will find a stencil which can be used to create another design.

m muñition arm muñition arm muñition art

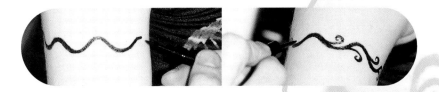

you will need...

... a *friend* to help you!

... tattoo inks and a *fine art* brush or temporary mehndi *body ink* (see page 94) or liquid eyeliner

... *talcum powder* to set (if using eyeliner or tattoo ink)

For a slightly different look, use the *stencil* on the front flap of the cover and follow instructions.

1 To ensure that your design circles your arm perfectly, use a loose elastic band as a guide to get a neat horizontal line.

2 Draw a wavy line carefully around your upper arm.

3 Add decorative flourishes and curls at regular intervals along the circling band.

4 Finish with little dots above and below.

Removal

Tattoo inks – rubbing alcohol or a lot of soap and water.

Body paint, or temporary mehndi body ink – soap and water.

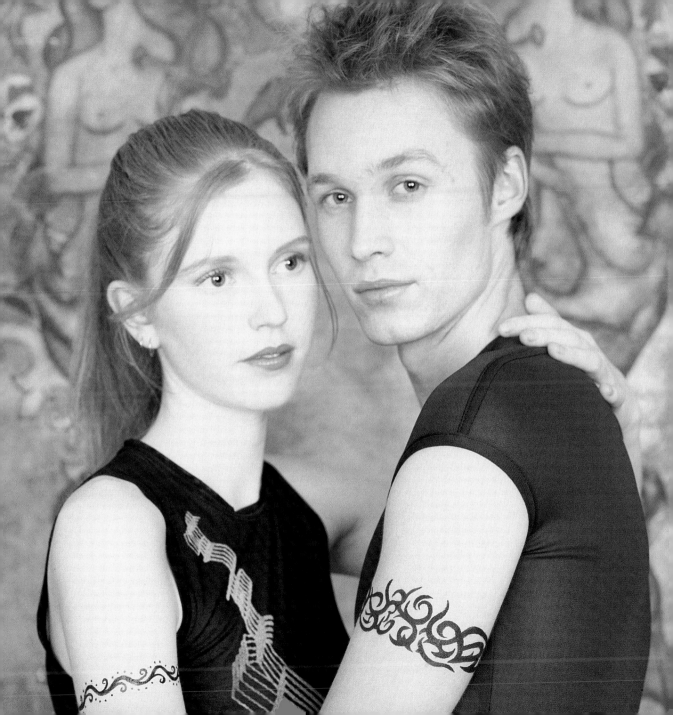

The Chinese character 'double joy' is used in China at weddings as it means great happiness and the two elements of the word's design also allude to the joining of man and wife.

"double joy" **"double joy"** "double joy" "double

you will need...

... black body paint or black tattoo ink ... a fine art brush ... talcum powder to set

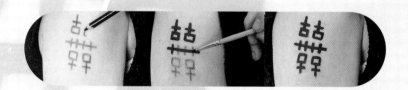

1 Sketch a rough outline of the character in kohl pencil.

2 In paint or ink, follow the photographs to achieve the finished look.

3 Using talcum powder and a powder puff, lightly dust the design to set it.

Removal

Tattoo inks – rubbing alcohol or a lot of soap and water.
Body paint – soap and water.

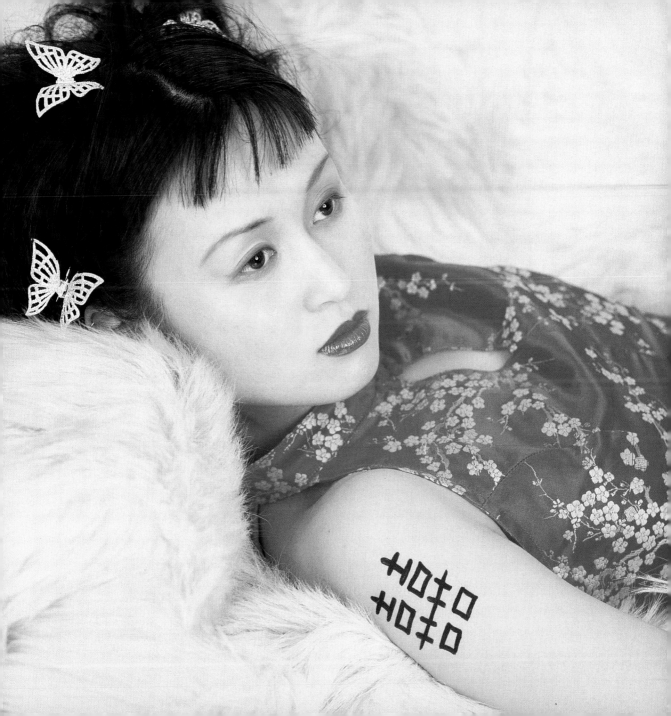

This is a variation on the infamous knuckle tattoos 'love' and 'hate'. To ring the changes you could write the words on your nails. Hearts have been used in tattoo designs for centuries. They look great in any form, painted anywhere on the body. Try a simple red heart on your upper arm or a black heart-shaped beauty spot on your cheek!

emotions mixed emotions mixed emotion

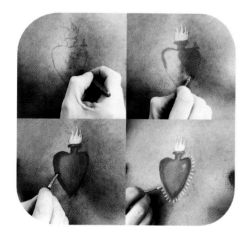

you will need (for the hands)...

... either *white mehndi* or
 white body paint

... a fine *brush*

1 Carefully spell out 'love' and 'hate' on to your left and right hands.

you will need (for flaming heart on the chest) ...

... a kohl *pencil* ... a fine brush ... a *fill-in brush*

... selection of *body/face* paints – red, black, yellow and white

1 Sketch out heart shape in pencil.

2 With the fill-in brush, paint the heart red and add yellow for the flames.

3 Add a little black to the red to darken it, then add in some shading around the outer edges to add a little depth.

4 Add thin white lines radiating from the heart with the fine brush.

5 Using the same brush and black paint, add the ring of thorns.

6 Powder and set.

Removal

Body paint – soap and water.

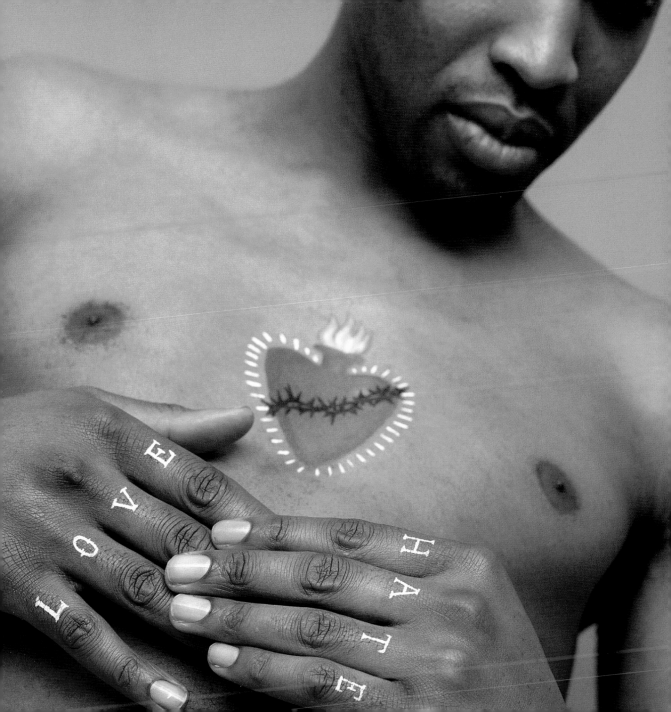

Quite often bold is best. Revealing a simple cross can knock 'em dead. We show how to create a Celtic cross below but you could try a Maltese cross, or an Egyptian ankh (see right, T-shaped, with a loop above the horizontal bar) to symbolise 'life'.

star-crossed lovers star-crossed l

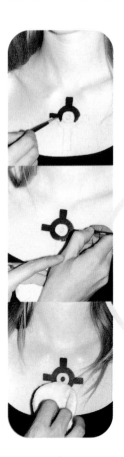

you will need...

... body paint or *tattoo ink*
 (we used black)

... a *fine* art brush

... *talcum powder* to set

1 Prepare the skin by wiping with astringent to remove grease or moisturiser.

2 Sketch out your design lightly with a kohl pencil.

3 Using a fine brush, begin to fill in with body paint or tattoo ink.

4 When finished, set by gently patting with talcum powder.

Removal

Tattoo inks – rubbing alcohol or a lot of soap and water.

Body paint – soap and water.

26

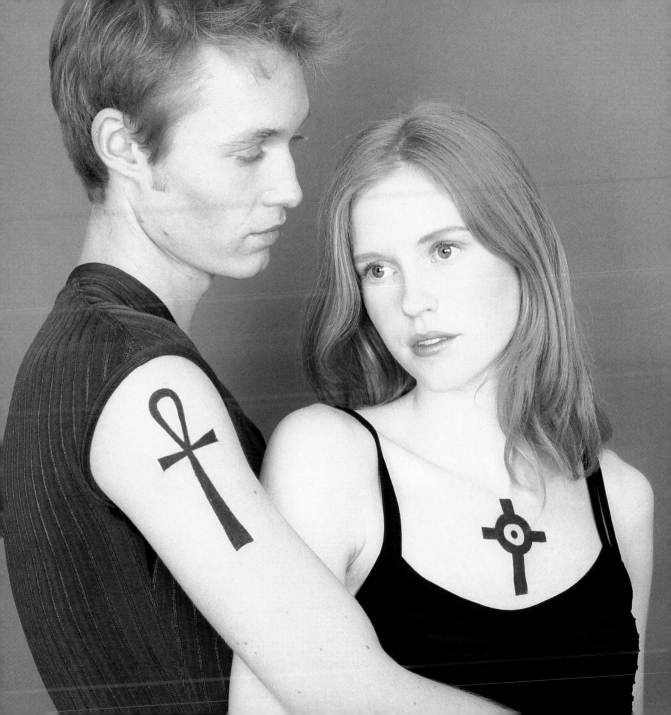

This stunning design is based on the geometrical shapes of Inca designs. You could paint it or use a commercial transfer. Circling the belly button is an excellent way of getting a pierce noticed or even showing off a well-toned tum!

ica stains inca inca stains stains inca stains in

you will need...

... a transfer (see page 94 for stockists) ... scissors ... a brush or cotton tip ... water

1 Cut out the desired transfer and remove backing paper (cutting out the centre will help you to position it around the belly button).

2 Place image right-side down on to skin.

3 Using a paint brush or cotton tip, wet the back of transfer with water until it is soaked through, being careful not to move it!

4 Apply firm pressure for 20 seconds or so, then carefully peel back a corner of the paper to check that the image has totally stuck to the skin. If it has not then apply more water and pressure. When it has stuck remove the paper backing carefully.

5 Smooth out any wrinkles or air bubbles while it is wet with your fingertips and allow to dry.

Removal

Transfer – baby oil, rubbing alcohol or soap and water. If it is a really stubborn one sometimes sticky tape comes in handy to lift it!

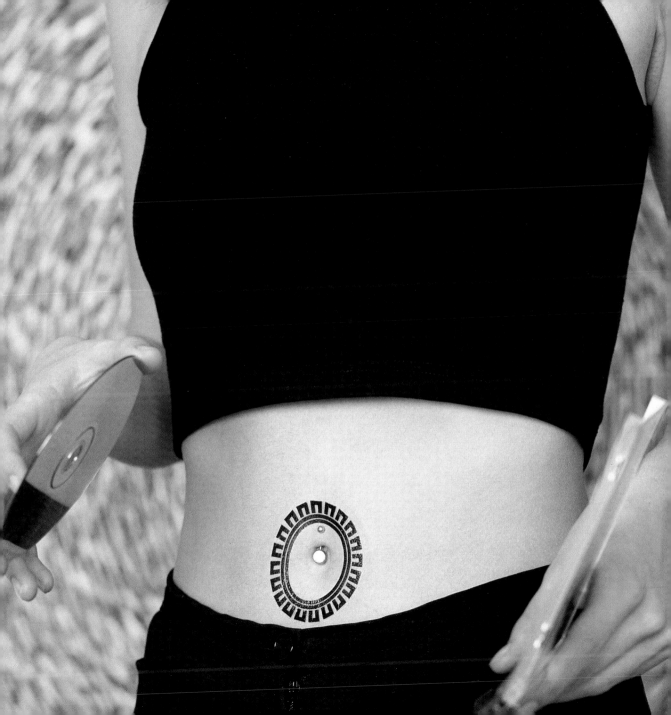

Want to feel a bit of animal magnetism? Try sporting a cool design on the part of your body you want noticed and see what happens. There are many temporary tattoos available which offer designs such as panthers, dolphins, snakes, turtles, tigers... try the iguana stencil on the back flap.

guana! iguana! iguana! iguana! iguana! i

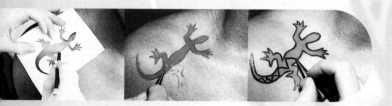

you will need...

... stencil on back flap of cover

... a craft knife

... a good cutting surface

... a kohl pencil

... body paint (we used red and black)

... a fine art brush

... talcum powder

1 Cut out the stencil from the back flap using a good cutting surface and a craft knife.

2 Place the stencil against the skin in the desired position then trace the stencil on to the skin with the kohl pencil to form an outline.

3 Remove stencil and fill in the design with body paint.

4 Using a fine brush and black body paint, outline the image and add decorative markings.

5 Using talcum powder and a powder puff, lightly dust the design to set it.

Removal

Body paint – soap and water.

30

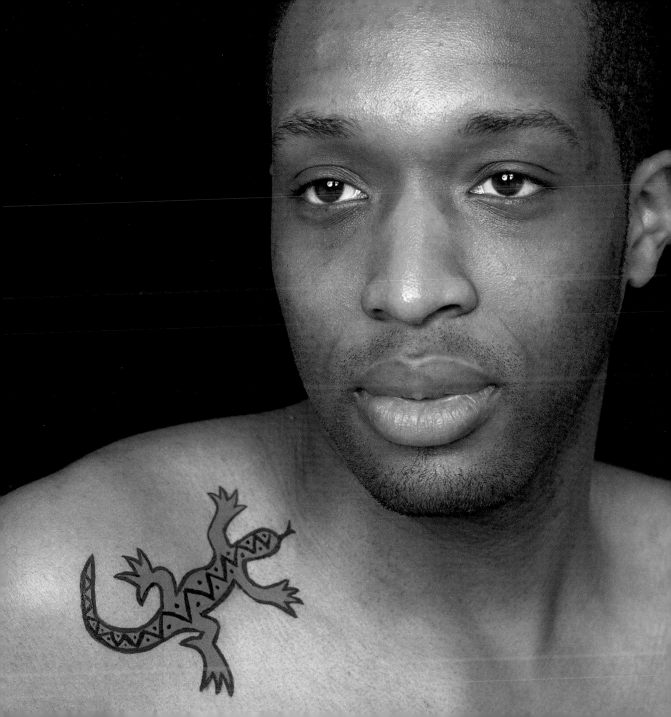

Some accidents are just waiting to happen. Therefore dangerous areas should carry a visible warning sign at all times!

arning radiation warning radiation war

1 Use the stencil on the back flap of the cover. Or, if using a commercial transfer, follow the manufacturer's instructions, see also below...

2 Cut out the desired transfer and remove backing paper. Place image right-side down on to skin.

3 Using a paint brush or cotton tip, wet the back of transfer with water until it is soaked through.

4 Apply firm pressure for 20 seconds or so, then carefully peel back a corner of the paper to check that the image has totally stuck to the skin. If it has not then apply more water and pressure. When it has stuck remove the paper backing carefully. Smooth out any wrinkles or air bubble while it is wet with your fingertips and allow to dry.

Removal

Transfer – baby oil, rubbing alcohol or soap and water. If it is a really stubborn one sometimes sticky tape comes in handy to lift it!

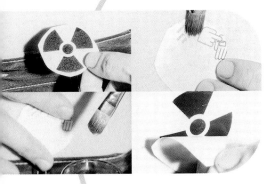

you will need...

... a transfer (see page 94 for stockist)

... scissors

... a brush or cotton tip

... water

32

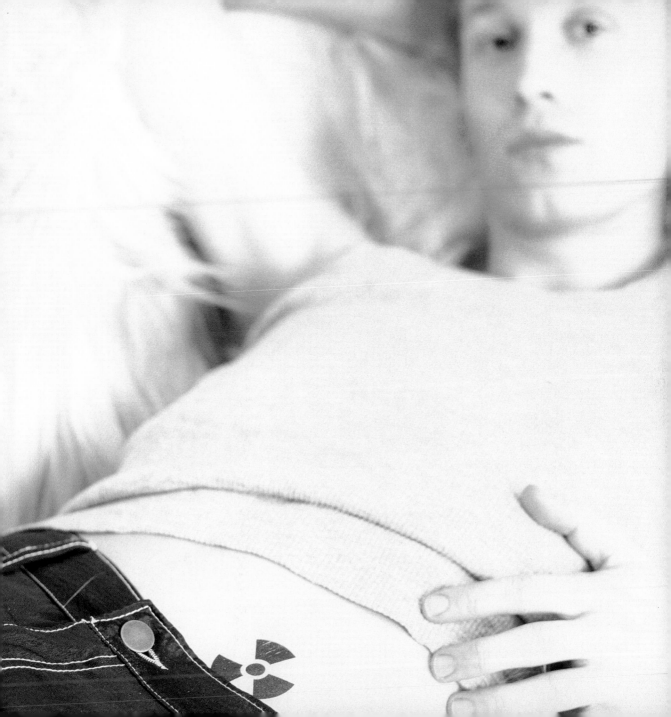

A simple butterfly design can look amazing on a shoulder or ankle. Once you've mastered this design, why not try other animal shapes such as dolphins or snakes.

fly with me come fly with me come fly w

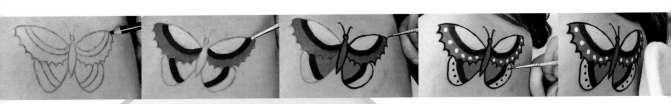

you will need...

... a *kohl* pencil

... 3-5 colours of: body paint, tattoo inks or you could use *face paints* (we used red, yellow, white, and blue)

... black, as above, to *outline* your design

... a *fine* art brush

... talcum powder

1 Prepare the skin by wiping with astringent to remove grease or moisturiser.

2 Lightly sketch an outline of the butterfly in kohl.

3 Fill in with your colours, rinsing your brush between each colour.

4 With a fine brush, go over your outlines in black to make your design stand out.

5 Using talcum powder and a powder puff, lightly dust the design to set it.

Removal

Body/face paint – soap and water.

Tattoo inks – rubbing alcohol or a lot of soap and water.

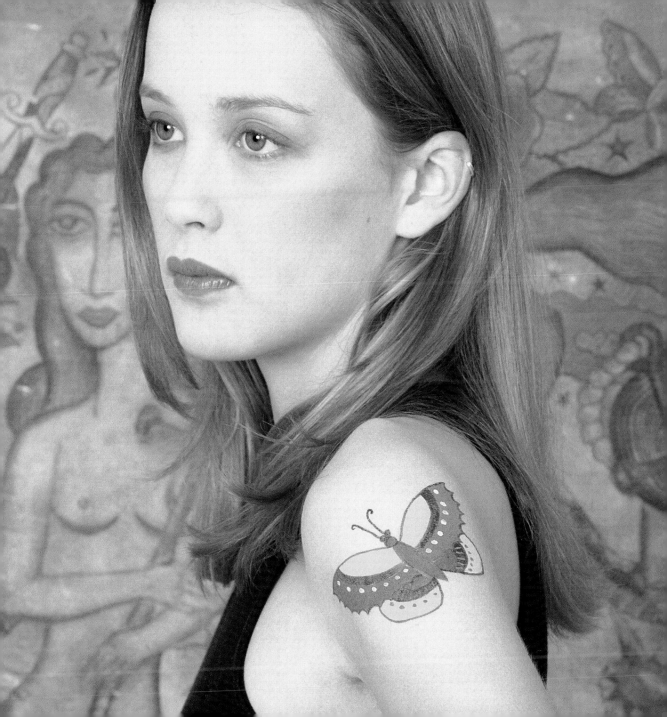

Keep tabs on the one you love with this barcode design. You can buy a commercial transfer, but if you feel brave and are full of artistic merit then paint it up yourself (using a very fine paintbrush).

check out chic

you will need...

... a transfer (see page 94 for stockist)

... scissors

... a brush or cotton tip

... water

1 Cut out the desired transfer and remove backing paper.

2 Place image-side down on to skin.

3 Using a paint brush or cotton tip, wet the back of transfer with water until it is soaked through, being careful not to move it!

4 Apply firm pressure for 20 seconds or so, then carefully peel back a corner of the paper to check that the image has totally stuck to the skin. If it has not then apply more water and pressure. When it has stuck remove the paper backing carefully.

5 Smooth out any wrinkles or air bubbles while it is wet with your fingertips and allow to dry.

Removal

Transfer – baby oil, rubbing alcohol or soap and water. If it is a really stubborn one sometimes sticky tape comes in handy to lift it!

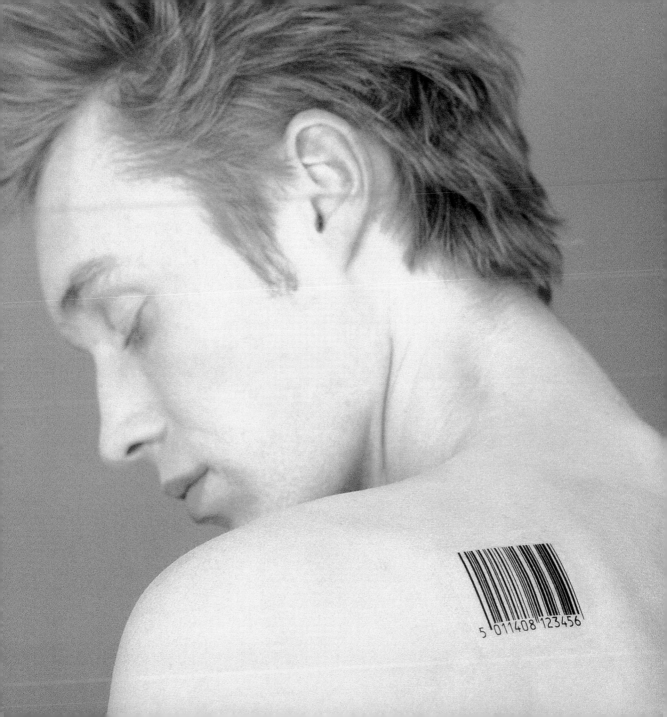

5 011408 123456

As henna tattoos become more prevalent, dare to bare a freeform design using one of the countless 'henna-type' products available on the market. Real henna will last up to two weeks but if you just want a design for an evening, then try one of the temporary cosmetics (see page 11 for more details). A more hippy design like this suits loose plaited hair and dreadlocks.

vine lines

you will need...

... a 'henna ink' (see page 94 for stockists) or brown tattoo ink and a fine art brush.

1 Start by deciding where your design should begin and end.

2 With a steady hand, draw a simple wavy line to form the basis of your design.

3 Then add keyline leaf shapes on either side. Make the line of your design as long as you like.

Removal

Henna ink – Soap and water.

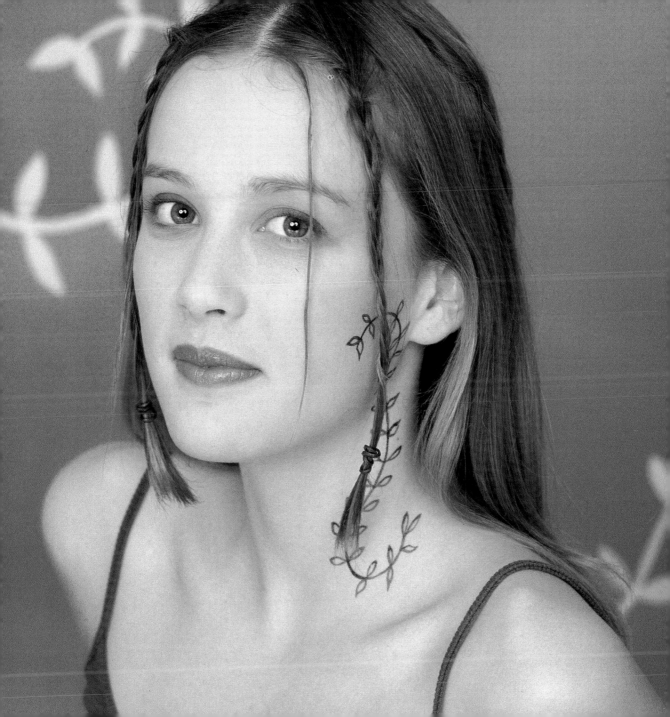

in addition to the many henna inks available, there is a large variety of 'henna transfers' which are useful if you are in a hurry or if you don't fancy your skills with a paint brush or henna pen.

trendy mehndi # trendy mehndi trendy me

you will need...

... a henna transfer
(see page 94 for stockists)

... scissors

... alternatively, you could use a 'henna' pen or tattoo inks and follow the application instructions on page 36

1 Cut out transfer and remove backing paper.

2 Position transfer sticky-side down on the skin and smooth out with your fingers.

3 Carefully peel back the transfer top sheet ensuring that image has adhered to skin.

4 Check transfer and smooth out any wrinkles or air bubbles with your fingertips.

Removal

Transfer – baby oil, rubbing alcohol or soap and water. If it is a really stubborn one sometimes sticky tape comes in handy to lift it!

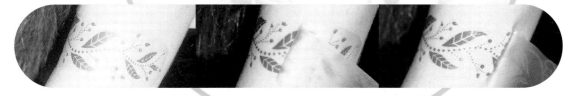

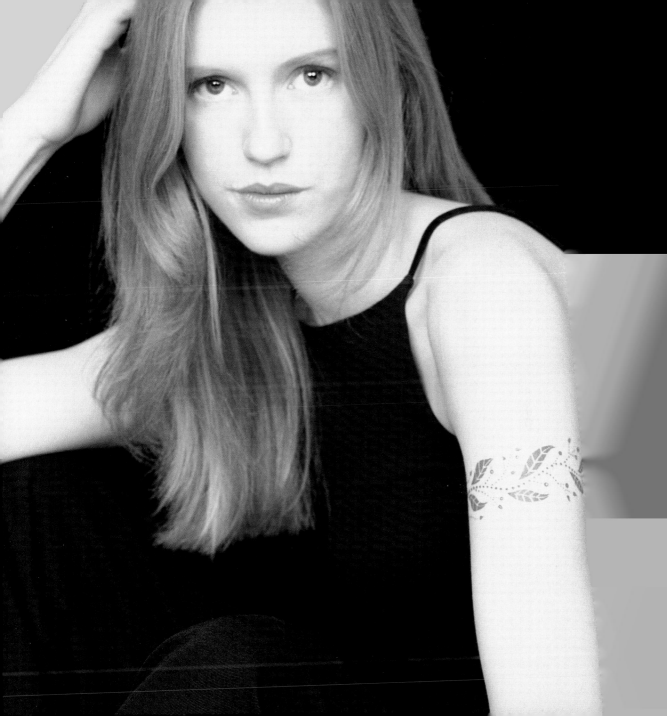

Black and white is an eyecatching combination – try the 'yin yang' symbol for effect. White mehndi looks fab on black skin.

white on black white on black white on bla

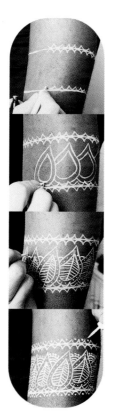

you will need...

... white mehndi (see page 11) or white body paint

... a fine brush

1 Start by drawing two lines about 4 inches (9 cms) apart, then add wavy lines above and below.

2 Paint simple overlapping teardrop shapes between the lines, then add inner keylines.

3 Draw in 3 curved lines between shapes and add flourishes.

4 Finish off the design by adding flourishes and dots to the tops and bottoms of both borders.

Removal

Body paint and mehndi – wash off design with soap and water.

42

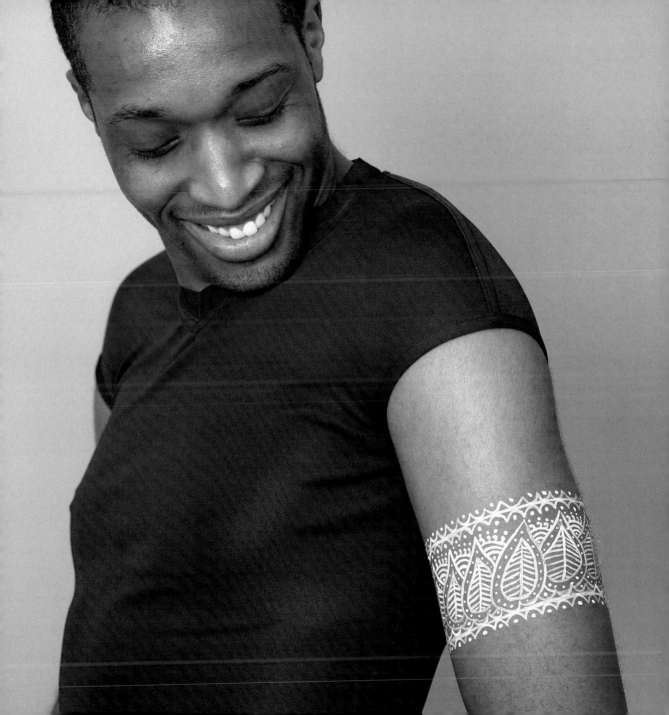

These designs are perfect for all you hippie chicks, and as summer progresses, let your inspiration carry your designs further afield.

med off **palmed off** palmed off palmed off palmed

you will need...

... a 'henna ink' (see page 94 for stockists) or brown tattoo ink

... a fine art brush

1 Start by deciding where your design should begin and end.

2 With a steady hand, draw a basic wavy line down the inside of your arm to form the basis of your design.

3 Then add simple keyline leaf shapes on either side. Remember to branch off around the wrists.

4 Draw a flower design in the centre of your palms. NB! try to avoid washing your hands if you want the design to stay on (it is only semi-permanent).

5 If you have used tattoo inks then with talcum powder and a powder puff, lightly dust the design to set it.

Removal

Tattoo inks – rubbing alcohol or a lot of soap and water.
Body paint – soap and water.

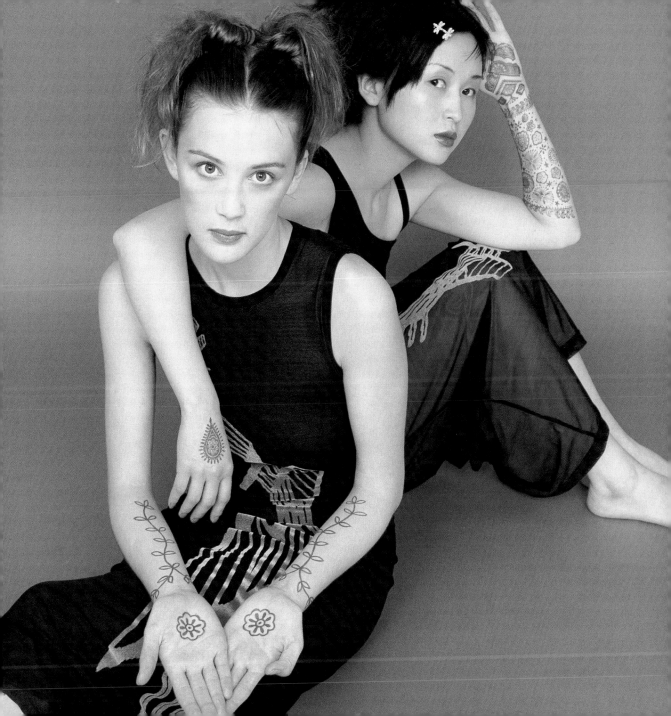

Delicate lines of mehndi can be used to build up beautifully intricate designs on your palms and the back of the hands. Just doodle away and watch the design appear before your eyes. Of course there is nothing to beat real henna for authenticity and staying power (designs can last up to 3-4 weeks!) but it is tricky to use and takes a while to execute. See page 10 for more details.

reward # handsome reward handsome rew.

you will need...

... one of the available henna-look products such as henna ink pen (see page 94 for stockists) or real henna paste

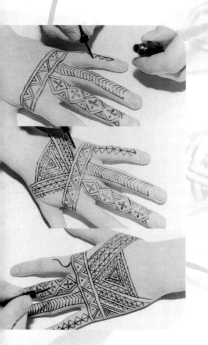

General instructions

Let your imagination run riot. If you like doodling you will enjoy this exercise (you can adorn the inside of your palm, nails and even carry the design on up your arms). You may need a friend to help you work on the hand you write with!

Sketch the basic structure to your design first then gradually fill in the details, making it as simple or intricate as you wish.

NB! try to avoid washing your hands if you want the design to stay on (it is only semi-permanent).

Removal

Henna ink – soap and water.
Real henna – only time can tell!

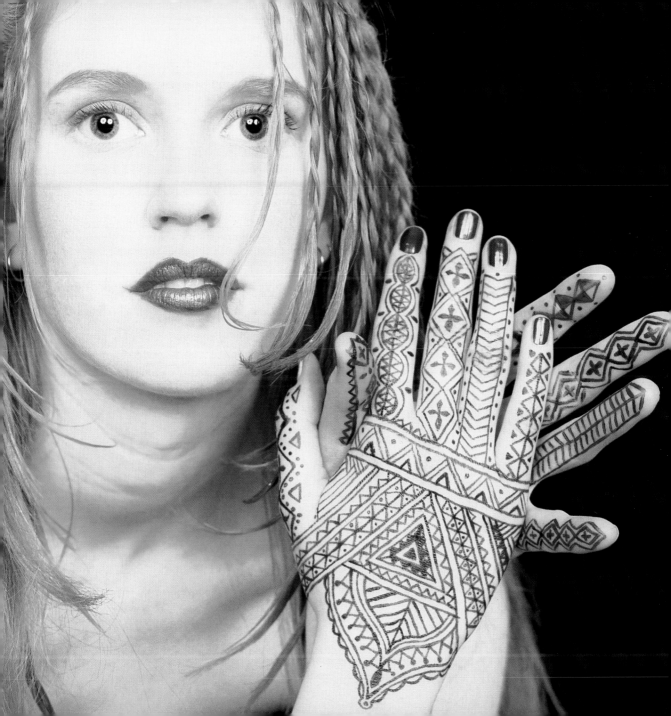

If you are worried that you don't have a steady hand, then create amazing nail art designs using a combination of nail varnish and commmercial transfers or nail stickers (see page 94 for stockists).

petal pusher

etal pusher petal pusher petal pusher petal pus

you will need...

... a base coat of nail polish (we used pearly white)

... commercial nail transfers (see page 94 for stockists). We used rub-down transfer daisy designs but you could use other types and follow manufacturer's instructions

... scissors

... an orange stick

... a clear nail polish to seal the design

1 Apply desired base coat. Ensure that the polish is completely dry before the next step.

2 Position transfer on nail and firmly rub the back of the transfer with an orange stick.

3 Remove backing paper, smooth down any edges with your finger tips and apply clear top coat.

Removal

Transfer and polish – nail polish remover.

48

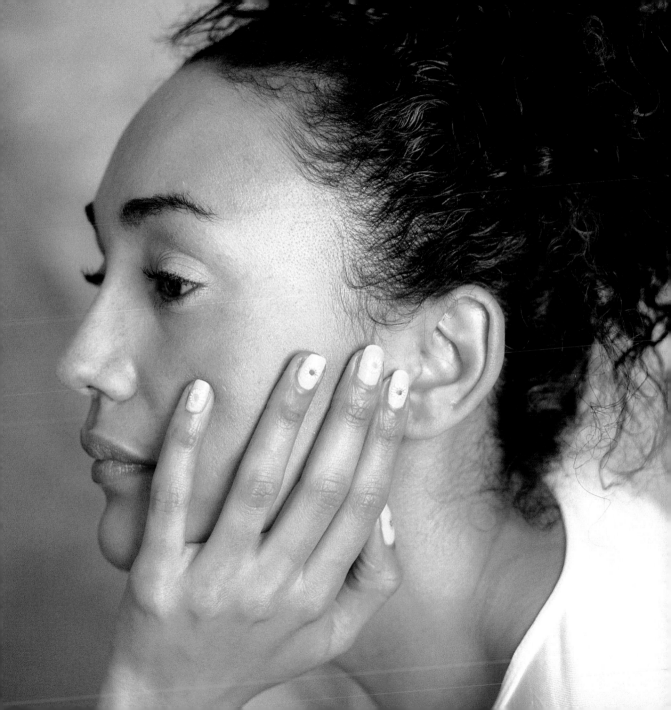

This is a variation on the 'french manicure' theme where the tips of the nails are painted white. In fact this design works stunningly with any combination of colours giving a subtle look whilst jazzing up your normal nail varnish.

two-timer two-timer two-timer **two-timer** two-timer two t

1 Apply your desired main colour. You want to fill three quarters of the area from the base of the nail. Try to achieve a neat horizontal line (using the edge of a piece of scrap paper as a guide may help).

2 Paint the tips with your contrasting colour, without spoiling your straight edges.

3 When your design is dry seal it with a top coat of clear varnish.

Removal

Nail polish – nail polish remover.

you will need...

... 2 colours of nail polish
(we used royal blue and ice blue)

... a clear nail polish to seal the
design

Glitter is BIG. It is available in every imaginable kind of cosmetic from powder to translucent gel. Add a little sparkle to your life and nails with some glitter varnish, available in all sorts of colours.

ght spark **some bright spark** some brigh

you will need…

… a base coat of nail polish to
boost the colour of the design
(we used silver)

… glitter nail varnish

1 Apply your base coat and let it dry.

2 Paint over your glitter varnish. You may find that you need to build up the glitter look with a few layers of varnish, waiting for a while between coats to get an even covering.

Removal

Nail polish – nail varnish remover.

If you haven't got much time then rub-down nail transfers are a great invention! Just pop them on top of your favourite nail colour – black works brilliantly with metallic transfers.

goldfinger

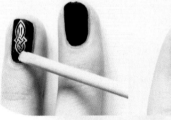
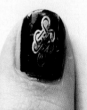

you will need...

... a *base* coat of nail polish (we used black)

... commercial *nail transfers* (see page 94 for stockists) we used gold rub-down transfer designs but you could use other types and follow manufacturers instructions

... *scissors*

... an *orange stick*

... a clear *nail polish* to seal the design

1 Apply desired base coat. Ensure that the polish is completely dry before the next step.

2 Position transfer on nail and firmly rub the back of the transfer with an orange stick.

3 Remove backing paper, smooth down any edges with your finger tips and apply clear top coat.

Removal

Transfer and polish – nail polish remover.

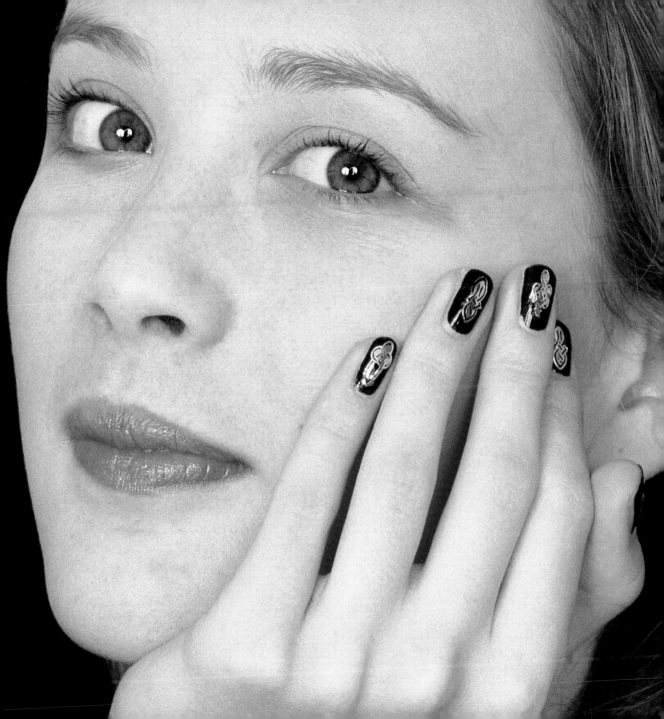

Hindu women traditionally wear a bindi as one of the sixteen classic beauty adornments. You can buy ready-made bindis of every colour of the rainbow from many Indian fashion retailers and now from many accessory shops. You can adapt them, paint your own or incorporate bought bindis (or **body jewels**) into your own painted designs as we have done below.

bindi babe
li babe bindi babe bindi babe bindi babe bind

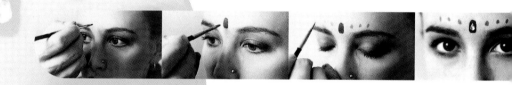

you will need...

... 2 contrasting colours in body/face paint.

... bindi/body jewel

... eye lash glue

... a medium paint brush

1 With a steady hand and your first colour, paint in the central mark just above your eyebrow.

2 Having rinsed your brush, paint a row of smaller dots following the line and curve of the eyebrows in your second colour.

3 Attach your jewel using eyelash adhesive, or fix your bindi to the central mark and gently push into place.

Removal

Bindi – carefully pick off jewels and keep for further use.
Body paint – soap and water.

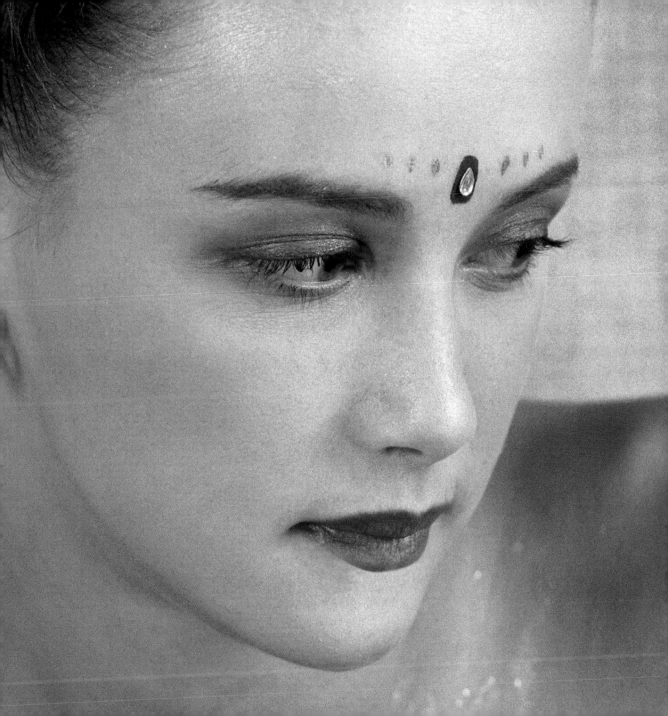

When the heat is on, create your very own signature bindi to reflect your personality or star sign!

fire the imagination

you will need...

... a self-adhesive bindi

... a fine brush

... red body paint

1 Select your bindi – the ones used here are self adhesive.

2 Carefully centre and place the bindi on forehead and apply firm pressure to ensure glue gets a hold.

3 With fine brush and red body paint, add a small flame mark above bindi.

Removal

Bindi – carefully pick off jewels and keep for further use.
Body paint – clean up with soap and water.

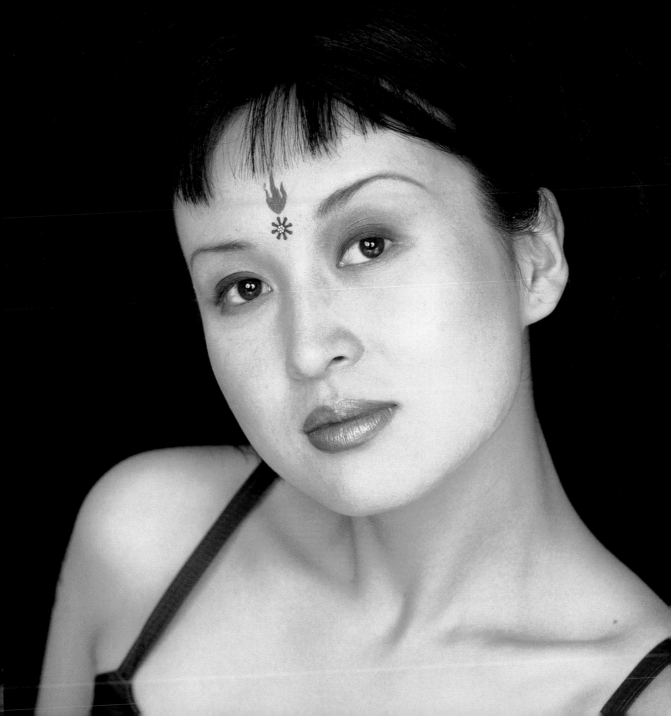

Stunningly simple and very effective. You can achieve the most amazing combinations with cosmetics, commercial bindis, facial jewels and sequins. Let your imagination work wonders – and get yourself noticed!

jewel personality

you will need...

... white body paint

... a *fine* brush

... a jewel

... eyelash adhesive

1 Using a fine brush and white body paint, paint your design onto the forehead ensuring it is centred.

2 Using an orange stick, attach a small dot of eyelash adhesive onto the back of your jewel and place onto your painted design. Apply light pressure to jewel. Alternatively, use a self-adhesive jewel readily available at Indian beauty shops.

Removal

Jewel – carefully pick off tand keep for further use.

Body/face paint – clean up with soap and water.

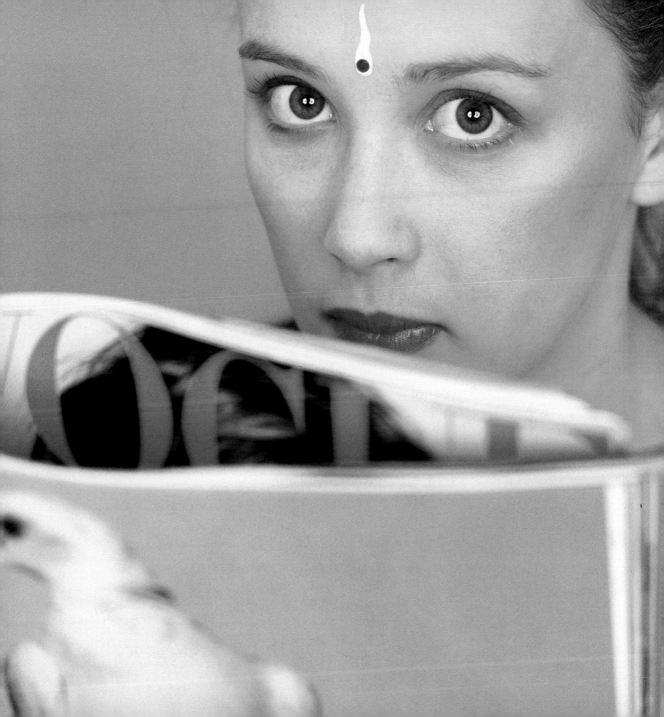

Body jewels are perfect for decorating any part of your body. Use them for complex bindis to reflect the curve of your eyebrows (as popularised by Gwen Stefani) or to accentuate cheekbones, eyeiids, nails, some of them even work well as a nose stud.

diamond life **diamond life** *diamond life diamon*

you will need...

... jewels or *sequins*

... eyelash adhesive

... *orange stick*

1 Select flat-backed jewels or sequins.

2 Apply eyelash adhesive to the end of an orange stick and carefully pick up your jewel transferring the glue onto the back of it.

3 Push jewel into position and carefully apply pressure. Pick off any unwanted excess glue with orange stick.

Removal

Jewels – carefully pick off and keep for further use.
Adhesive – clean skin with soap and water.

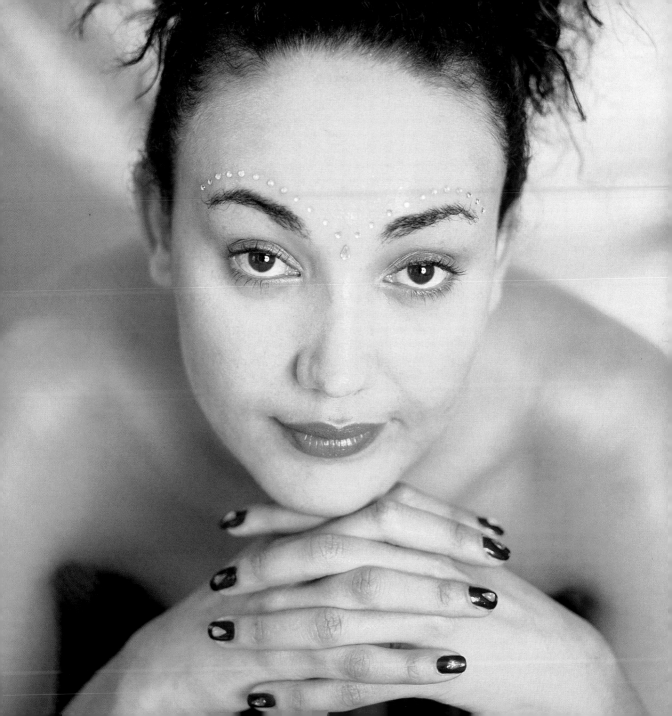

Sometimes you just want to go overboard on a look. Whether it is for a fancy dress party or a club. Use any colour you like and go mad! For an icy look like this, gather together glitter, diamond body jewels, silver pomade for the hair, silver eyemake up and lipstick and anything else that shimmers. The model's hair style was achieved by coiling and pinning up numerous plaits.

ble exposure

double exposure

double expos

you will need…

… silver body paint

… silver nail varnish

… silver hair pomade or hair mousse

… silver body jewels and glitter powder

… transparent glitter gel

… glittery false eyelashes

1 Prepare the skin with a good foundation and powder.

2 Colour the hair with pomade or coloured hair mousse.

3 Decorate your face with glitter powder, body jewels, the works…

4 Don't stop until you *know* that you are gonna stop everyone in their tracks!

Removal

Body paint – soap and water.
Hair pomade/mousse – shampoo.

Create a funky, retro look that is perfect for summer. This design can be extended down the back in a brilliant and colourful mass of flowers. For clubbing, try using neon body paints.

power flower power *flower power flower po*

you will need...

... a kohl pencil ... 3 or 4 different coloured in body paints ... a wider fill-in brush ... a *fine brush* ... talcum powder

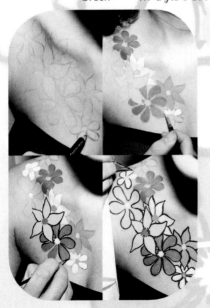

1 After wiping the skin with an astringent to remove any oil or moisturisers, begin pencilling in your chosen design with an eyebrow pencil.

2 Using the wider brush, fill in the flowers with body/face paint , going up to but not over your pencil guide lines.

3 With a fine brush and black body/face paint, carefully go over all your outlines.

4 Be careful not to lean on and smudge your design, steadying your hand on a tissue can be helpful.

5 Powder and set.

Removal

Body paint – soap and water.

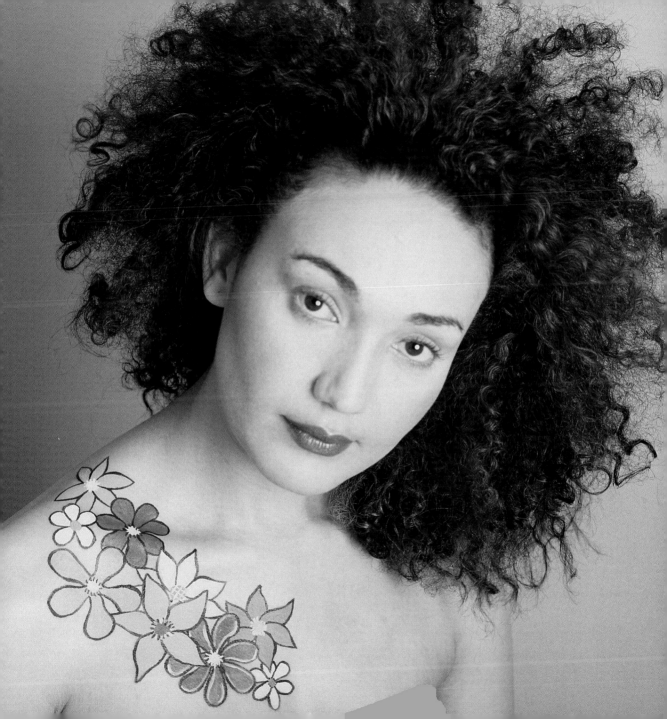

There are many fluorescent, ultraviolet and luminous body paints on the market which are a gift to clubbers. A must for those who live to be seen – even in the dark!

burning bright right burning bright burn

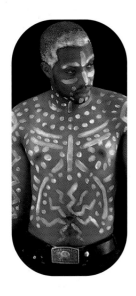

1 Smooth glow in the dark gel into hair.

2 Paint tribal markings or patterns onto the face and arms using fluorescent gel and brush.

Removal

Body paint – clean up with soap and water.

Hair gel – shampoo.

you will need...

... paint brush

... fluorescent (glow-in-the-dark) hair and body gel

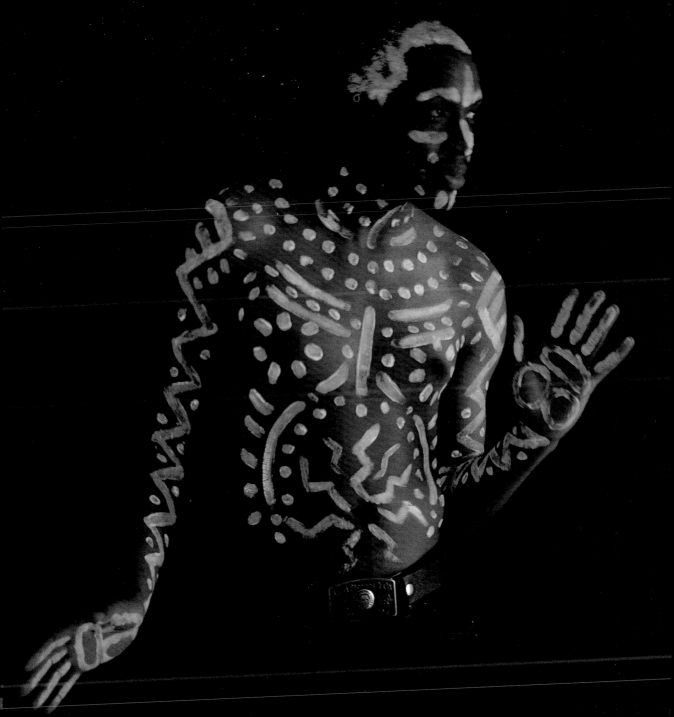

Spirals form the basis of many tattoo designs, particularly those of the South Pacific Islanders. These bold spirals make a great statement when used on the shoulder. Alternatively, link up smaller spirals to form an arm or leg band.

ervish # whirling dervish whirling dervish

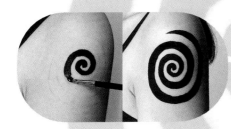

you will need…

… body paint or tattoo ink

… a *fill-in* brush

… talcum powder

1 Wipe area with astringent to remove oil or moisturiser and proceed to pencil in your design.

2 Using the brush, fill in your block colour with body paint or tattoo ink.

3 When finished, pat on talcum powder to set the image.

Removal

Body paint – soap and water.

Tattoo inks – rubbing alcohol.

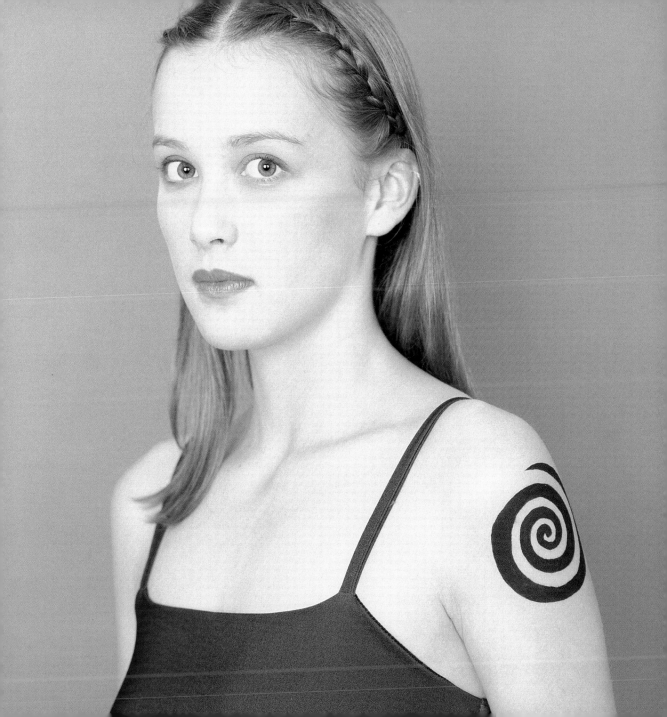

Metallic hair colours look great on short cropped hair and team up perfectly with our rocket design (see back flap). A cluster of stars by would also look good – paint them along the collar bone or down the neck...

am me up **beam me up** beam me up beam me up

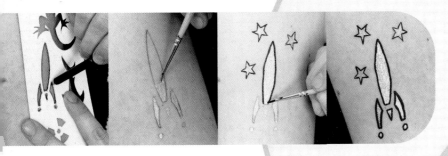

you will need...

... *golden* hair mousse

... rocket stencil *(ready cut)* see back flap of the cover

... a kohl pencil

... a *fine brush*

... gold body paint

... black body paint

1 Smooth mousse into hair following manufacturer's instructions.

2 Position stencil and outline in kohl pencil.

3 Fill in rocket in gold paint.

4 Outline rocket with black body paint and add stars.

Removal

Body paint – soap and water.

Hair mousse – shampoo.

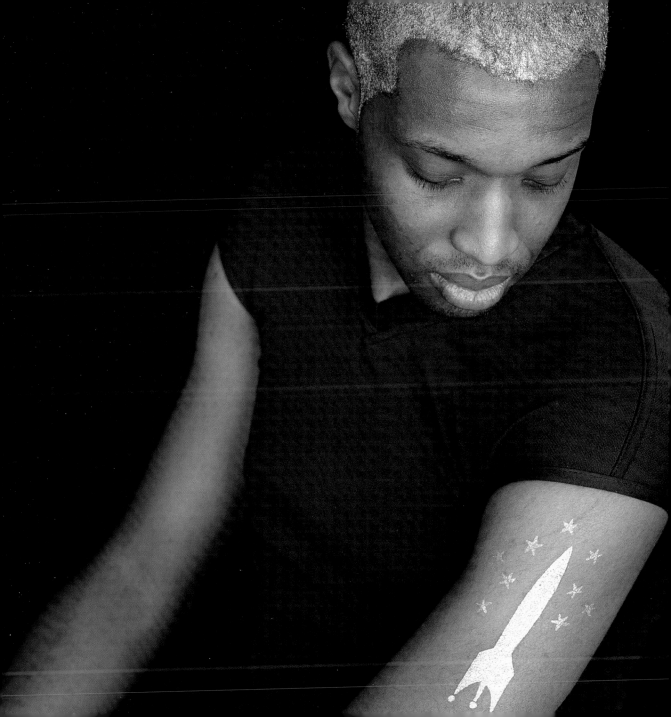

The art of using body paint lies in finding the perfect placement. The most important thing to remember is that you want to decorate the area of skin you would like to get noticed, but don't forget that body paint will smudge quite easily and certain pigments can stain clothing.

infested waters
infested infested waters i.

you will need...

... ready-cut stencil (see page 94)

... a kohl pencil

... red and black body paint

... a fine brush

... talcum powder

1 Using your ready-cut out shark stencil – trace around the inside of the image with the kohl pencil.

2 Remove stencil and fill in the area with red paint.

3 Go over the outline with the black kohl pencil or fine brush and black paint – powder and set.

Removal

Body paint – soap and water.

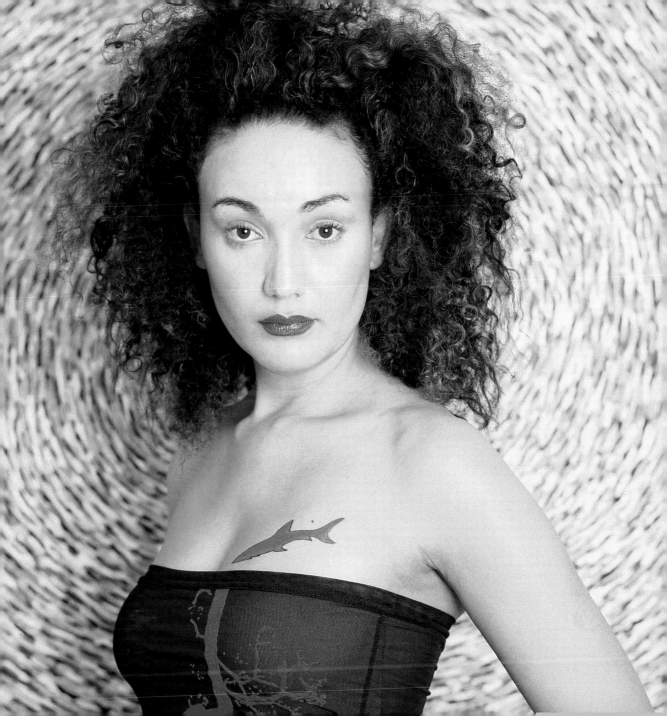

If you have a pierced bellybutton, this kind of design is perfect for drawing attention to it. Wear it with crop tops or a bikini on the beach.

body heat
body heat
body heat body heat body h

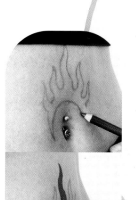

you will need...

... a *kohl* pencil

... body paint

... a *fine brush*

... talcum *powder*

1 Pencil out design with kohl pencil.

2 Fill in with blue body paint using a fine brush then powder lightly to set.

Removal

Body paint – soap and water.

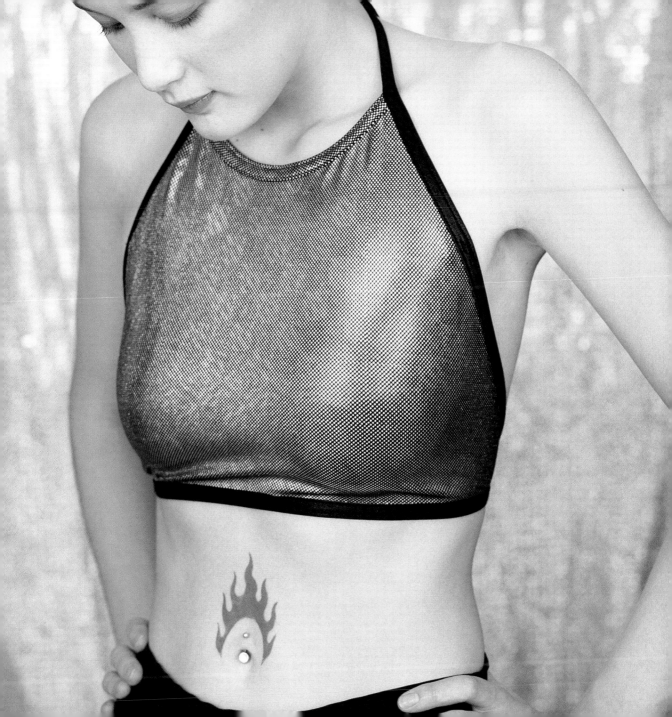

The hair slide is no longer restricted to the school yard. They are useful and fun – banishing a bad hair day in a trice. They also come in a myriad of styles and colours.

slip slidin' slip slidin' away slip slidin' away

you will need…

… a comb

… hair slide(s)

1 Use one to keep back a fringe, create balance with two or go crazy with many more…

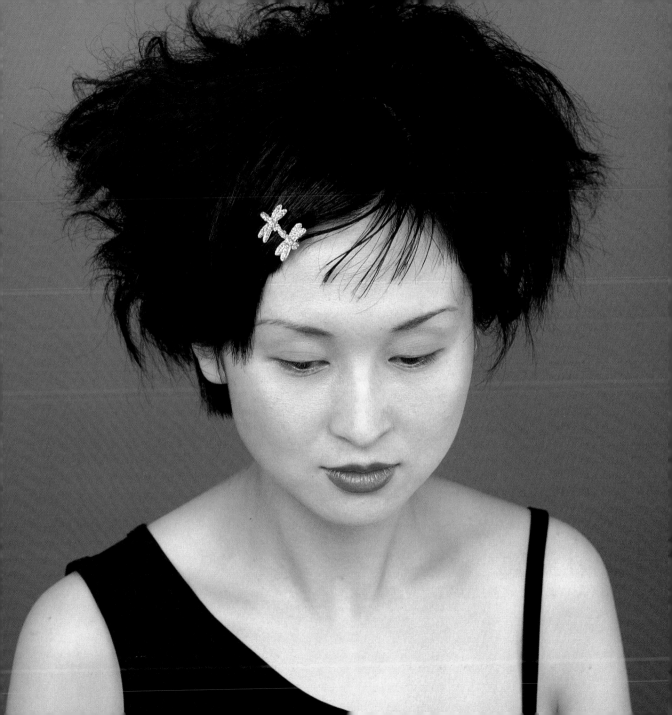

Immortalised by Björk, these little hair knots are here to stay. Believe it or knot they are not difficult to achieve, although it must be said that it is easier to rope in a pal to help you.

get knotted

t knotted get knotted get knott

you will need…

… a comb

… hair gel

… a water spray helps
 if you have one

… lots of hair grips to match
 your hair colour

1 Separate the hair into sections.

2 Wet each section and comb it out to remove any tangles.

3 Use gel to help you keep control of the hair.

4 Twist each section of hair until it begins to 'buckle'.

5 Coil the hair round into a knot and secure with 2 hair grips.to make a cross.

6 Wasn't that difficult was it!?

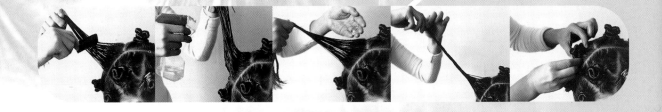

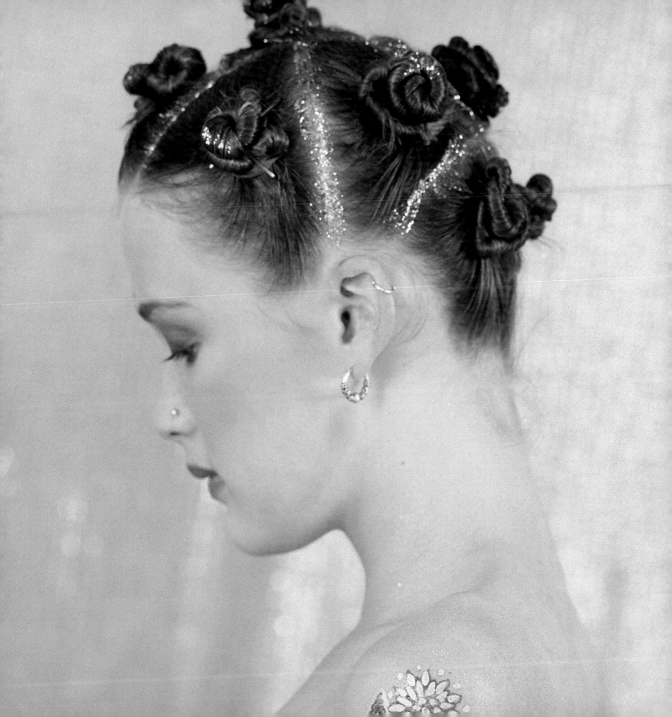

Hair mascara is a fab invention. It allows you to introduce one or more streaks of colour to your hair, with the added bonus that you can just wash it out at the end of the day! Choose a colour that contrasts with your hair (if the colour is too similar, you won't see it). Another way of introducing temporary colour if you have straight hair, is to spray colour through one of our stencils.

lucky streak ky streak lucky streak lucky str

you will need…

… commercial hair mascara (see page 94 for suppliers)

1 Section off the hair you want to colour.

2 Gently run the applicator from root to tip of the hair.

3 Repeat for a brighter, more vibrant colour.

4 Comb through once with a wide-toothed comb.

Removal

Hair mascara – shampoo.

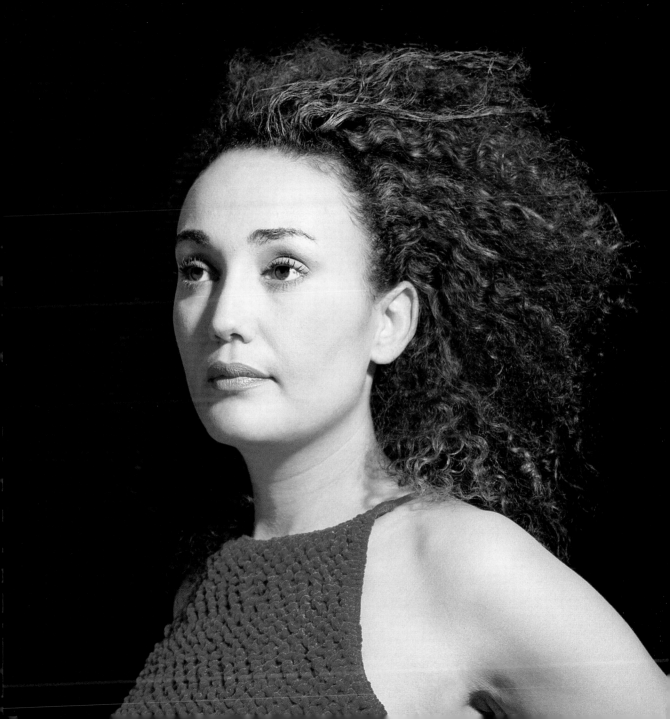

Butterfly clips are everywhere and their uses are endless. They're great if you're trying to grow out a fringe, or use them purely for decorative effect. Try using four or five clips to pull the hair away from your face.

madame butterfly madame butte

you will need...

... several *butterfly clips*

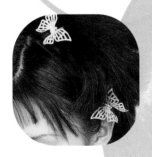

1 Comb small sections of hair away from your face and secure with a butterfly clip.

2 Use as many as you like.

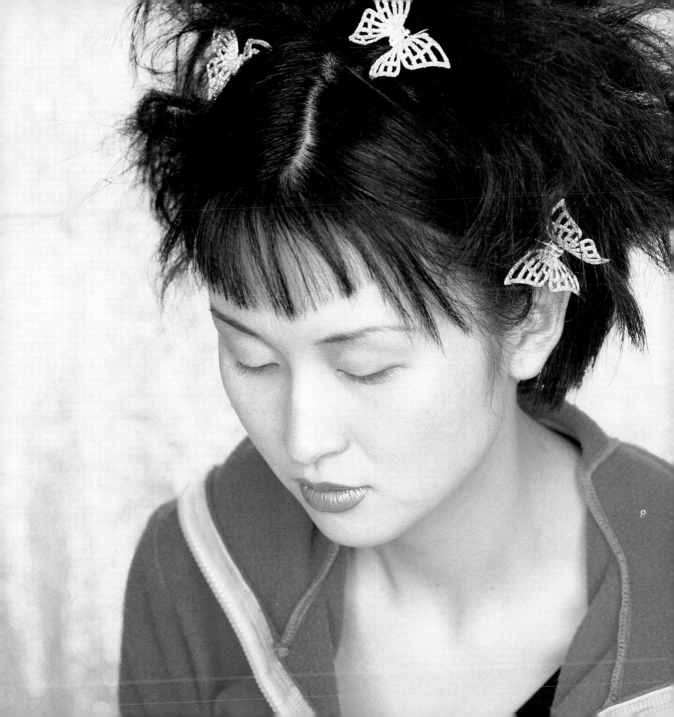

You will see many variations of this on the streets. You can either coil up your sections of hair into cone-shapes on your head or knot half the length of hair and backcomb the rest of the pigtail as we have done here.

top knotch

top knotch top knotch top knotch top

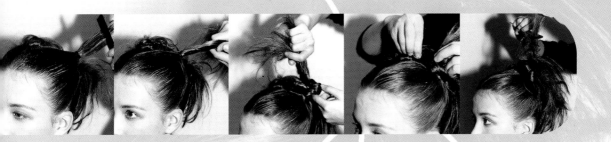

you will need...

... a comb

... two hair bands

... hair grips the colour of your hair

... some hair gel

... hairspray

1 Comb your two sections of hair and secure into pigtails with covered bands.

2 Use gel to help control the sections of hair.

3 Coil the hair tightly until the hair starts to curl towards your scalp and then secure the knot with hair grips leaving a length of hair hanging from the knot.

4 Set the design with a little hairspray.

5 Backcomb the ends of the hair.

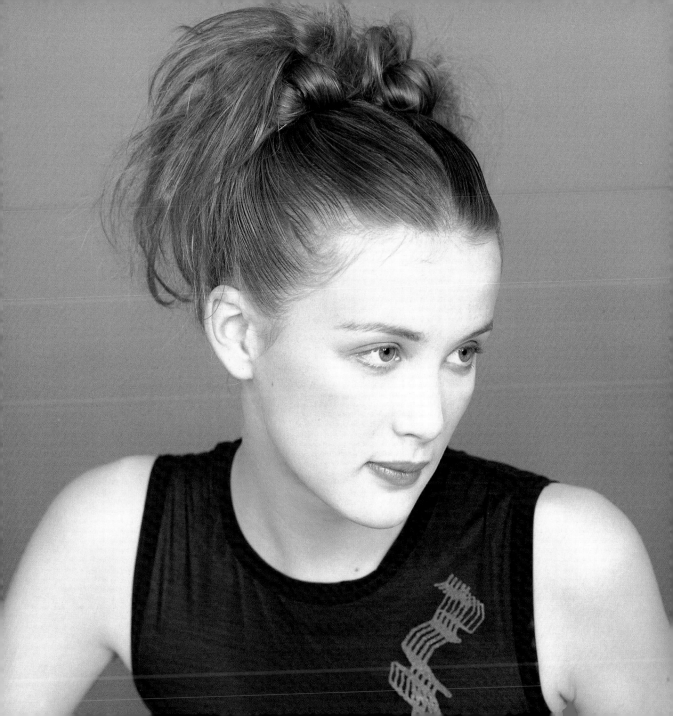

Originally sailors wore a single gold hoop in their ear to insure against the costs of their burial should they be drowned at sea and washed up on a beach. The current trend of sporting hoops, bars and studs through the nose and belly button, and even the tongue and eyebrow, has taken this highly visible form of body adormnent on to the streets and club scene. Even the children of British royalty have been known to indulge in the practice!

iercing look piercing look **piercing look** piercing look piercir

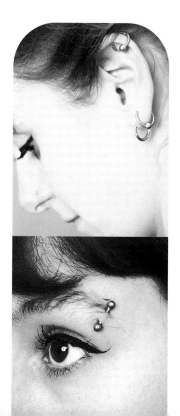

1 Don't get pierced on impulse! You must be over 16 anyway, and if you are under 18 you should get your parent's permission. Even then the piercing professional may still refuse to pierce you, so check first.

2 Find a reputable piercer through the Association of Professional Piercers (see information on page 19 and address on page 94).

3 Be sure to follow professional guidance on cleaning and aftercare to guard against infection.

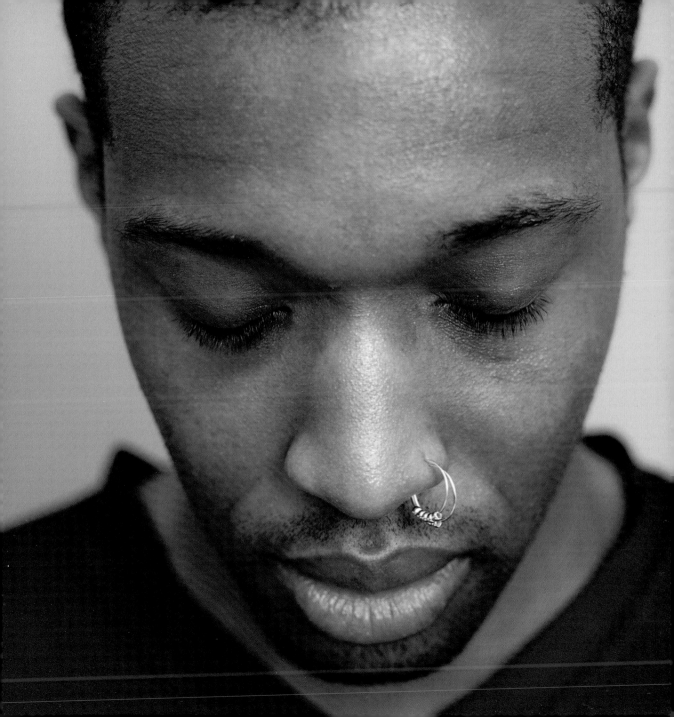

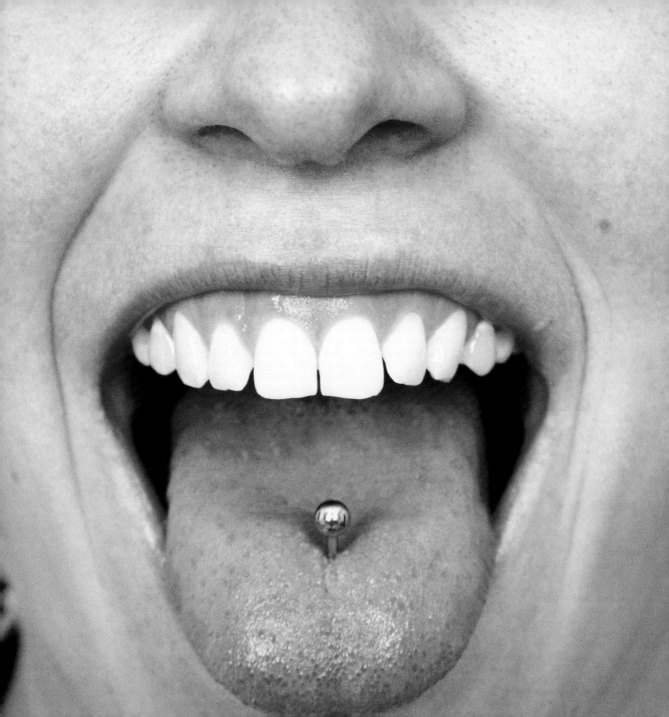

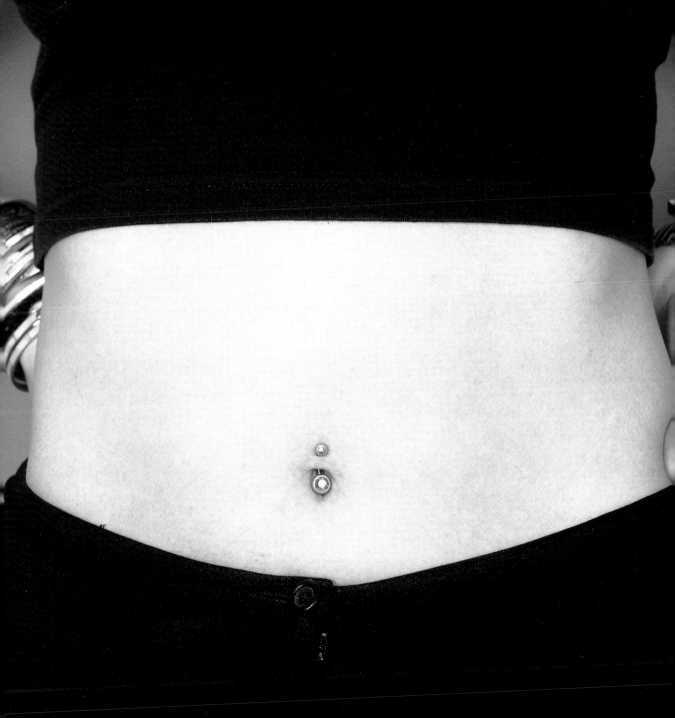

glossary
glossary glossary glossary glossary glossary

astringent removes greasy residue and moisturisers from the skin surface, which might otherwise resist or spoil your design.

rubbing alcohol or isopropyl alcohol (available from good beauty shops) removes grease paints and tattoo inks that resist soap and water.

setting powder (or talcum powder) helps the design to set by forming a thin translucent barrier to protect against smudges.

henna a natural, plant-derived pigment in various shades of red and brown. Leaves a semi-permanent marking which lasts between 1 and 4 weeks.

kohl pencil a very soft pencil used as eyeliner, available in different colours.

brushes quality brushes ranging from very fine to wider fill-in sizes are available from make-up and art shops. Always wash brushes immediately after use and reshape the bristles to prolong their life.

body/face paints grease- or water-based pigments. They come in a wide range of colours as well as fluorescent and dayglo.

temporary tatoo inks available in a range of translucent colours, they can look very realistic and are quite durable and waterproof.

reading # further reading further reading

1000 Tattoos Schiffmacher, Henk (Taschen) 1996

30 Nail Art Designs Tumblety, Susan (Milady Publishing) 1996

Body Art (Kyle Cathie Ltd) 1998

Body Painting Buis, Willem (Eurotique Press) 1997

Decorated Skin Groning, Carl (Thames & Hudson) 1997

Hot Tips: Step-By-Step Nail Art You Can Create at Home! Marion, Sandra &
 Moncion, Colette (Crown Pub) 1996

Mehndi: The Art of Henna Body Painting Fabius, Carine (Three Rivers Press) 1998

Mehndi: The Timeless Art of Henna Painting Roome, Loretta (St Martin's Press) 1998

Nails (Kyle Cathie Ltd) 1997

Nail Art Haab, Sherri (Klutz Press) 1997

Nail Art and Design Bigan, Tammy (Milady Publishing) 1993

Skin Shows 4 Wroblewski, Chris (Virgin) 1995

The Henna Body Art Book Marron, Aileen (Eddison.Sadd) 1998

stockists, products

ts products · stockis

Claire's Accessories
CBI Distributing Inc
2400 W Central Road
Hofman Estates, IL 60195-1930
847 765 4302 (fax)
*for body art, nail art & hair
accessories*

Galerie Lakaye
1741 N. Ivar Avenue ste.119
Los Angeles, CA 90028
323-460-7333 (phone)
*Distributors of henna hair
and body supplies*

L'Oréal
*have their own body art range
called 'ID' which includes
transfers, mehndi kits and
stencils, body art pencils
and hair color mousses
and mascara*

Medea Airbrush Products
79 SE Taylor
Portland, OR 97214
503-253-7308 (phone)
503 253 0721 (fax)
*Distributors of airbrush
products for the body and
nails*

Manic Panic
64 White Street
New York, NY 10013
212-941-0656 (phone)
*Distributors of temporary
hair dyes*

and useful addresses

addresses ... useful

Sacred Arts
365 Canal Street
New York, NY 10013
212-226-4286 (phone)
*Specializing in body
piercing, permanent and
temporary tattoos and
henna applications*

Temptu
26 W. 17th St. Ste. 503
New York, NY 10011
212 675 4000 (phone)
212 675 4075 (fax)
www.tempu.com
temptu@temptu.com
*for temporary tattoos, henna
and body art products
(catalog available)*

WEBSITES –
search under nail & body art.
see also:
*www.ziennails.com
www.bodyartsupply.com
www.earthhenna.com
www.henna-art.com
www.safepiercing.org
www.ritesofpassage.com*

acknowledgements

We would like to thank

the modelling agency **Angels** (+44 (0) 171 262 5344).

all our **models**: Anna, Cheryl, Demarcus, Leanna, Lotte, Nicola, Peter and Ruth.

our fantastic **hair and makeup artist** Yu Mei Chen who can be commissioned for projects in Taiwan and the UK (+44 (0) 171 840 8677).

De Nico of London clothes appearing on pages 27, 33 and 65.

L'Oréal: who provided the body art products for pages 1, 23, 29, 33, 37, 39, 43, 45, 47, 73 (hair mousse) and 83.

Suture clothes (+44 (0) 171 735 8772) on pages 21, 45, 67, 75, 87.

Barry Bish (+44 (0) 171 840 8791) is available to undertake commissions: painting on the human body, canvas, walls or floors. He painted the backdrops on pages 21, 29, 35, 39 and 75.

Michael Rose of Michael Rose Tattoo Studio (+44 (0) 181 447 0066) for all technical advice.